ALTITUDE

STEPRO BOOKS

PHOTO BOOK

"You haven't seen a tree until you've seen its shadow from the sky."
Amelia Earhart

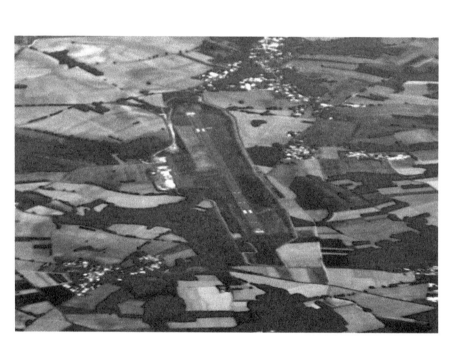

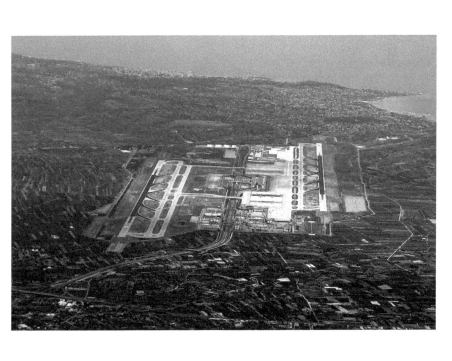

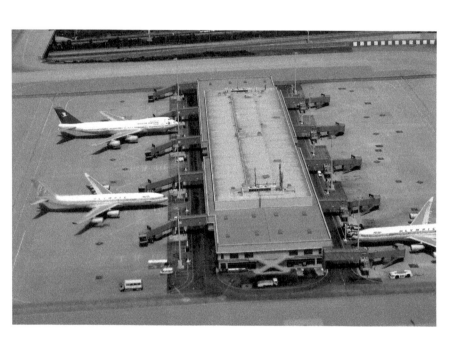

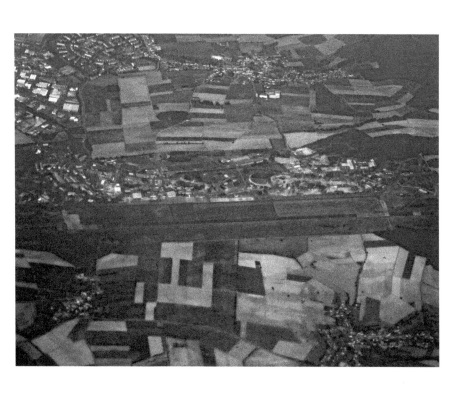

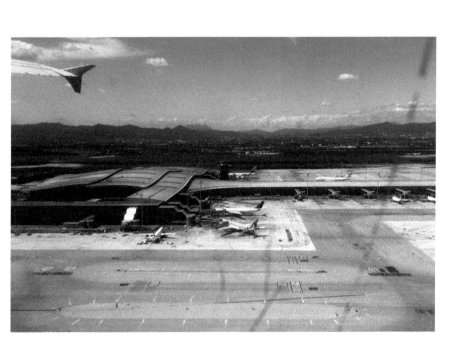

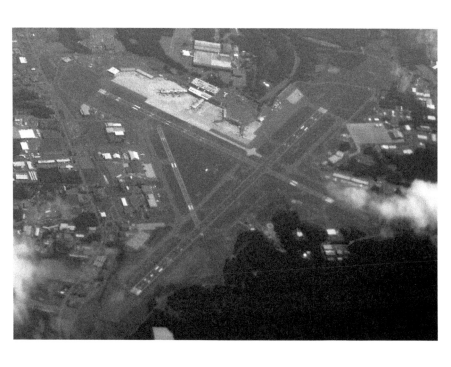

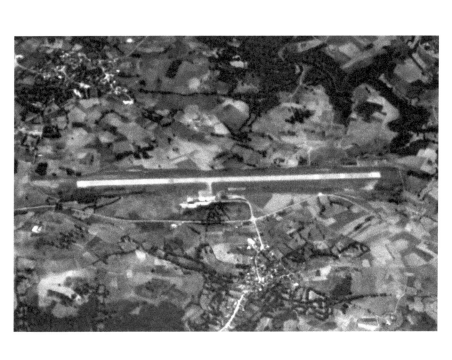

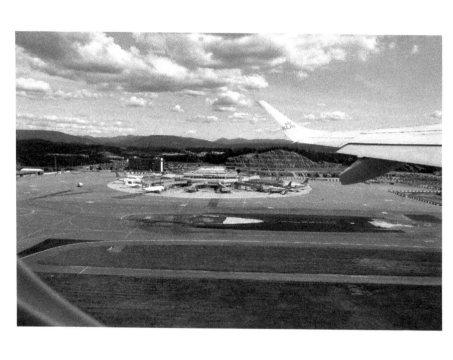

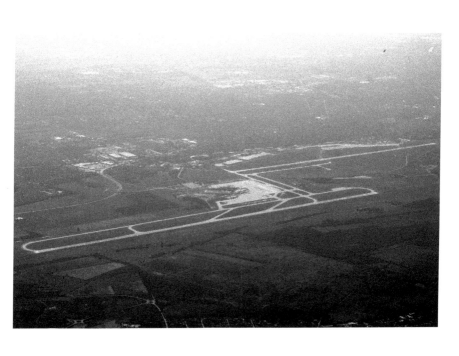

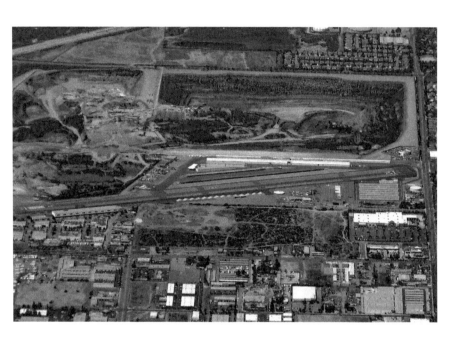

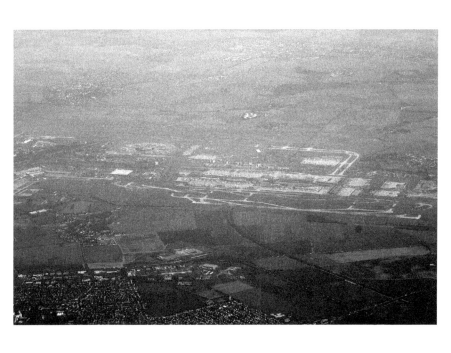

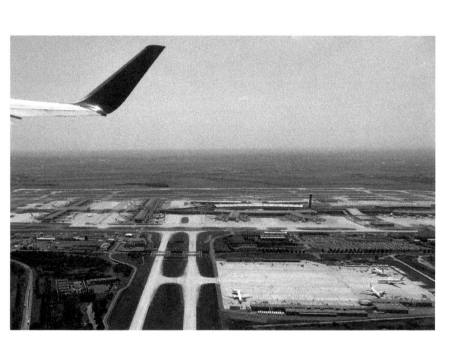

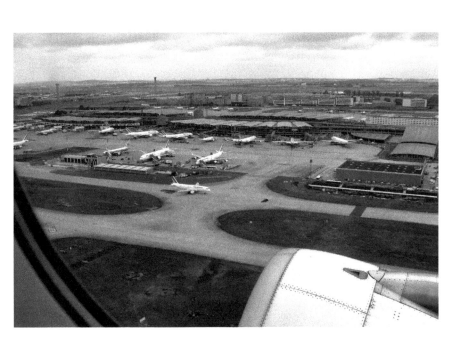

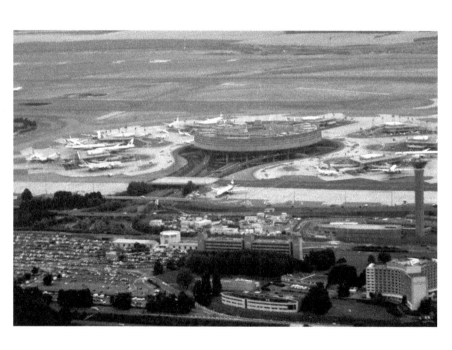

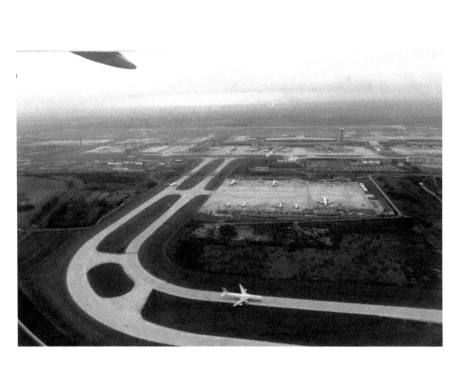

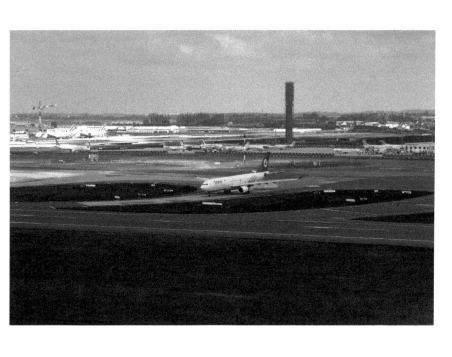

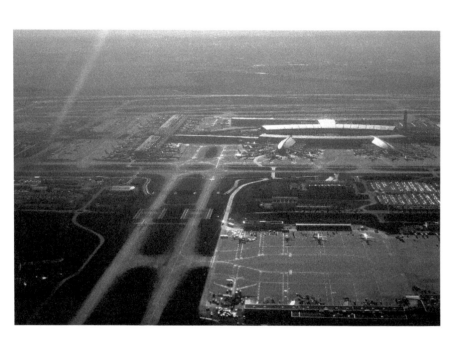

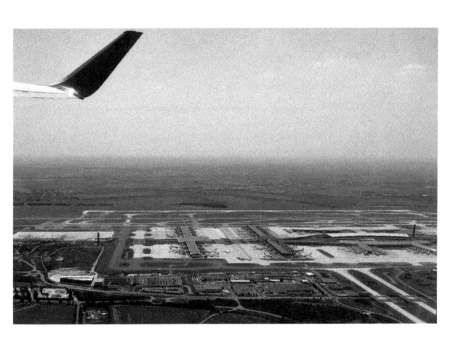

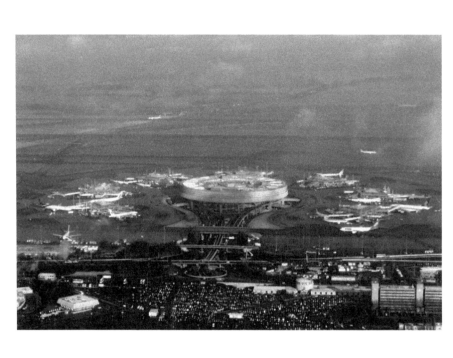

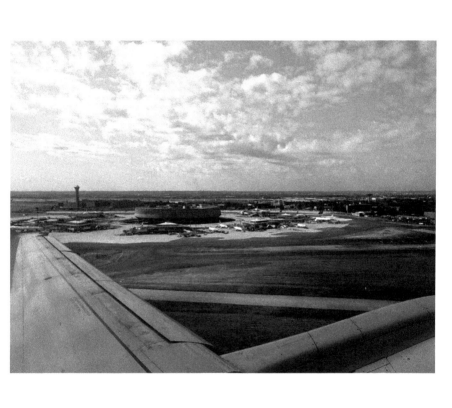

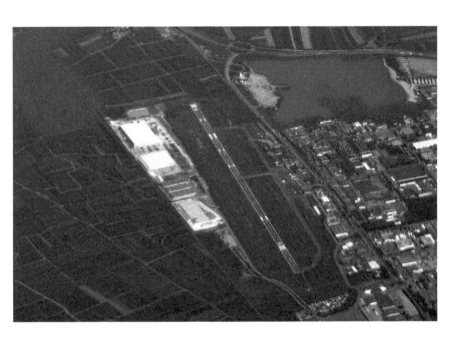

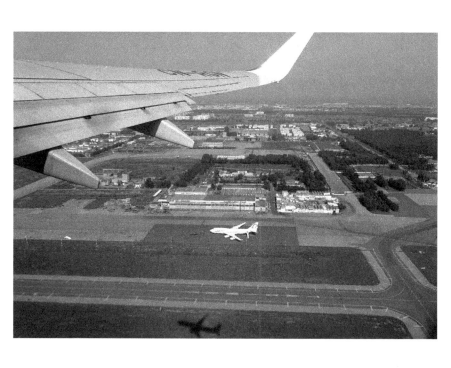

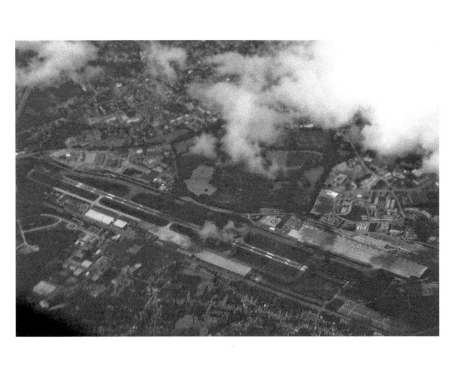

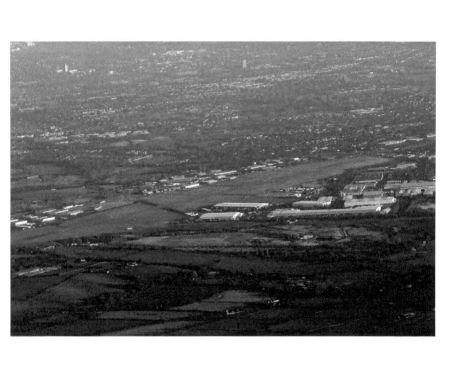

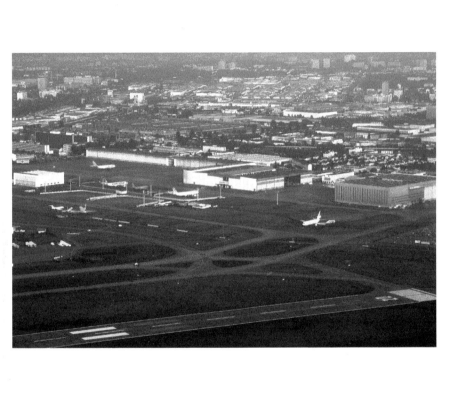

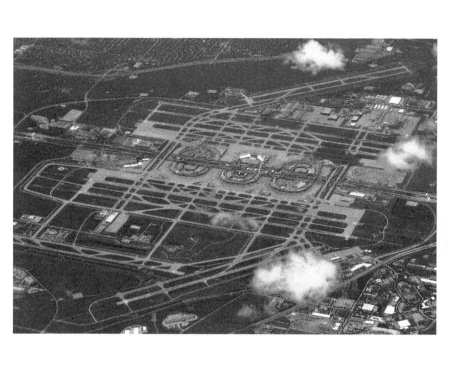

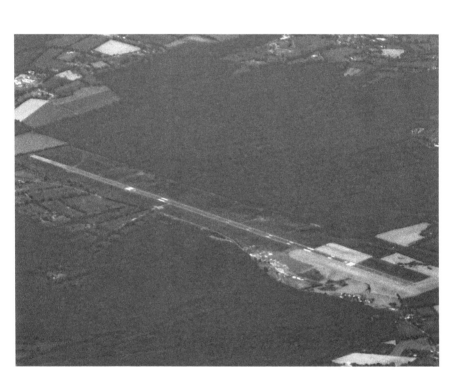

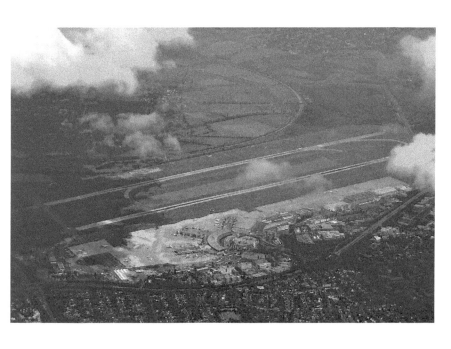

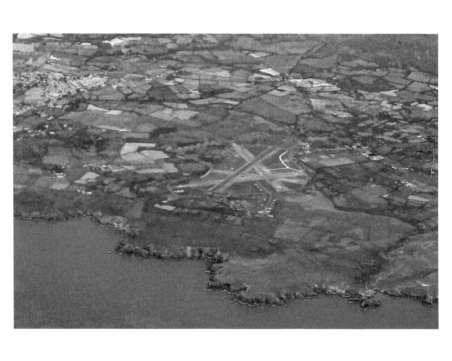

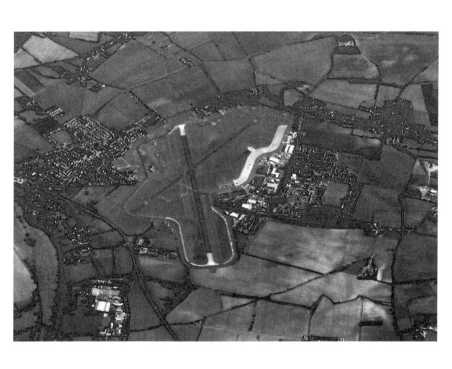

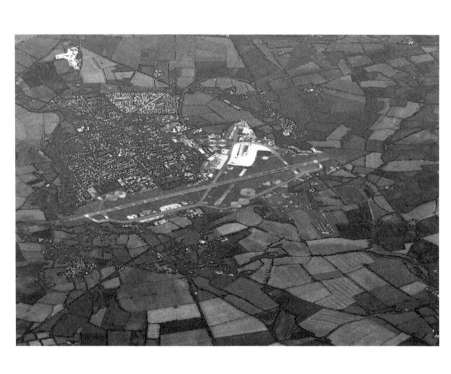

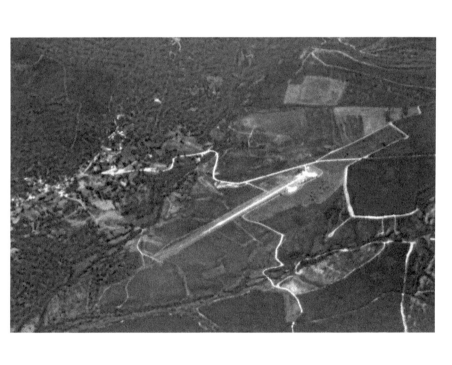

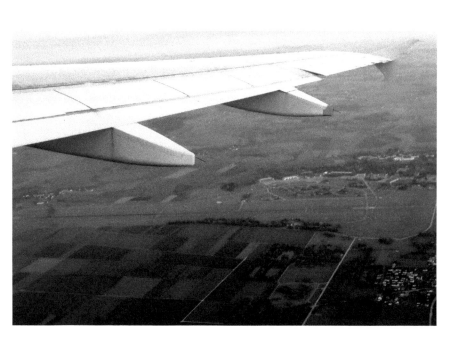

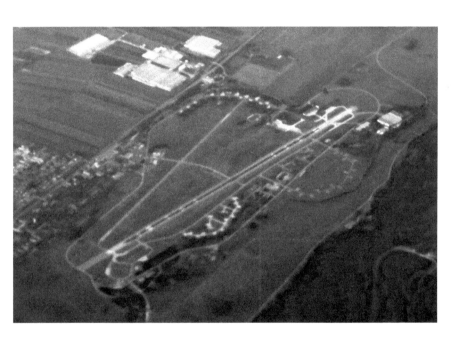

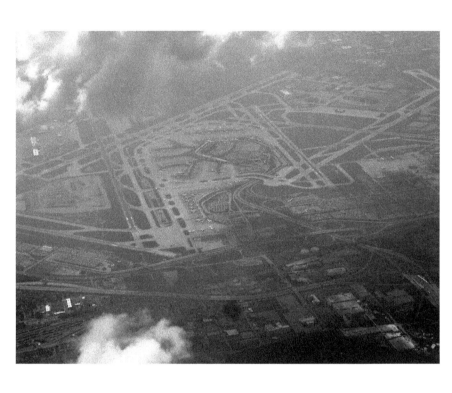

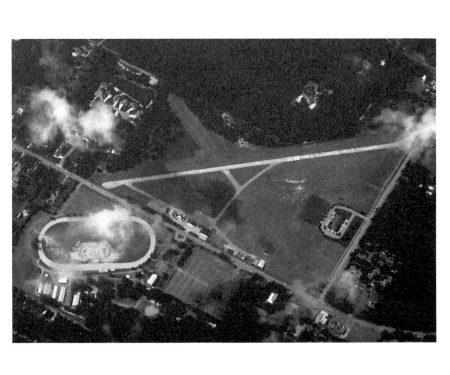

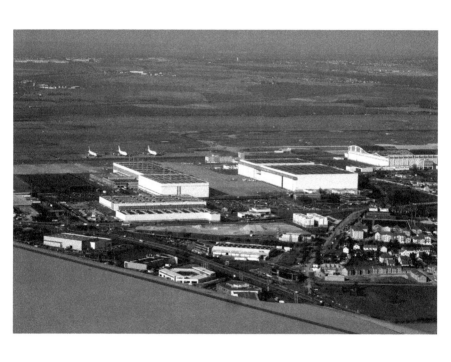

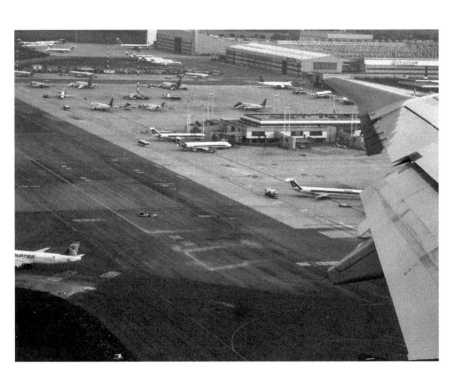

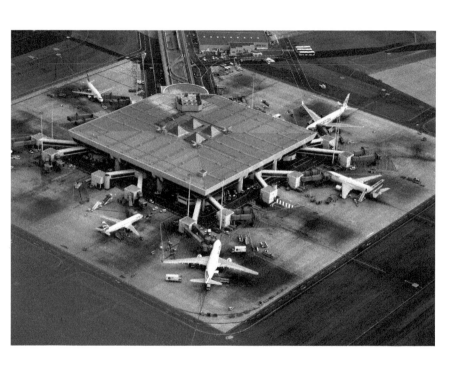

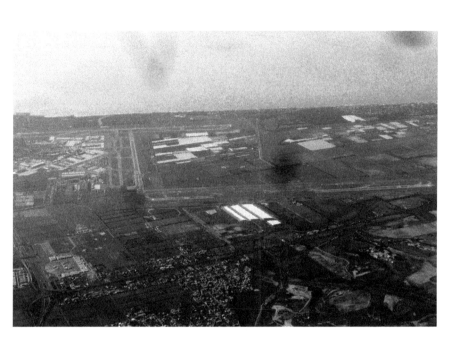

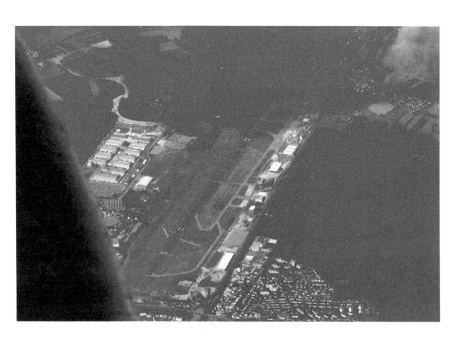

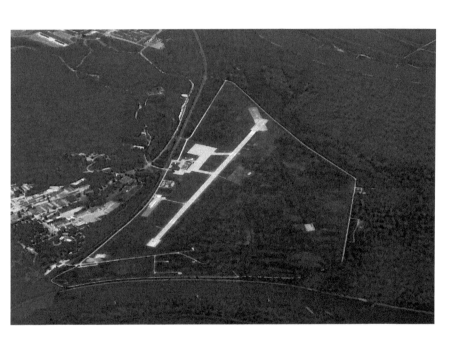

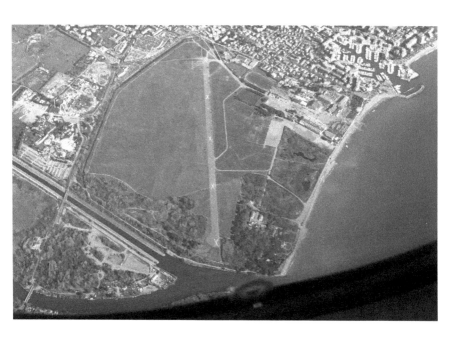

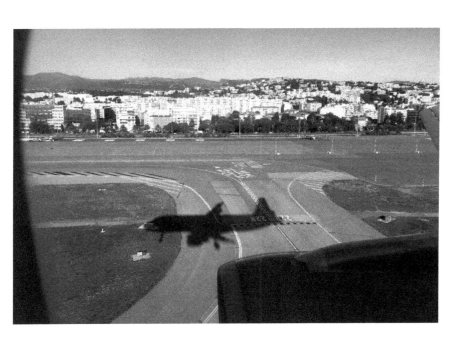

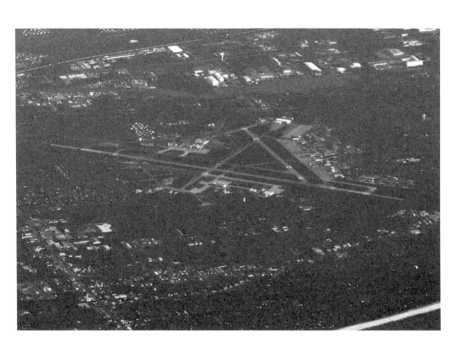

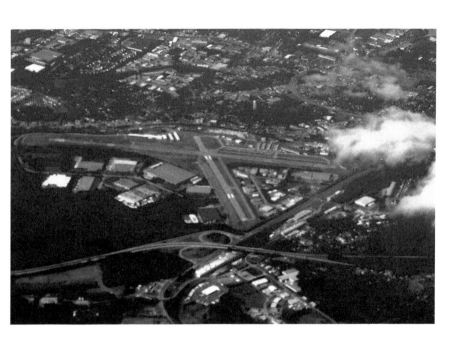

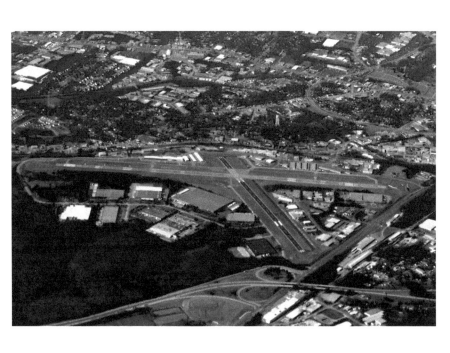

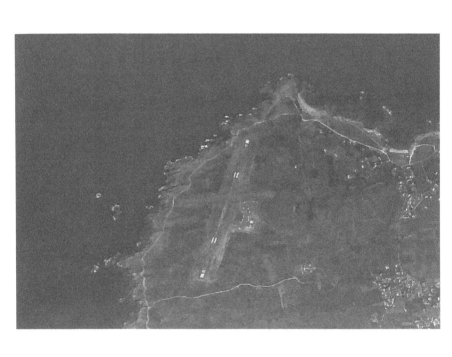

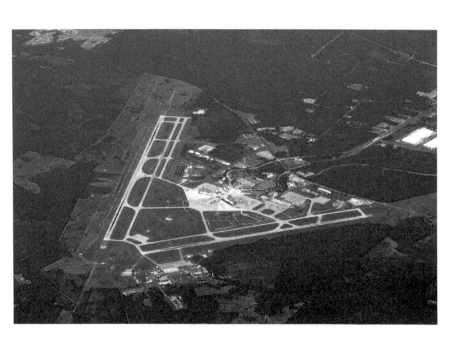

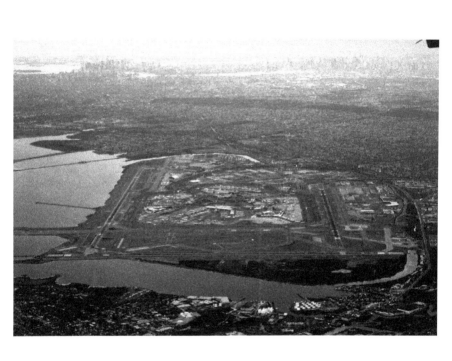

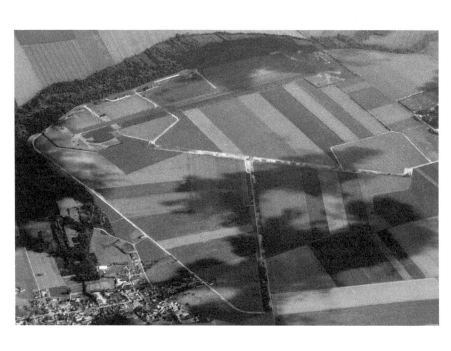

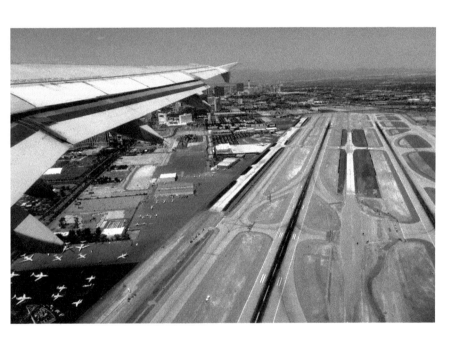

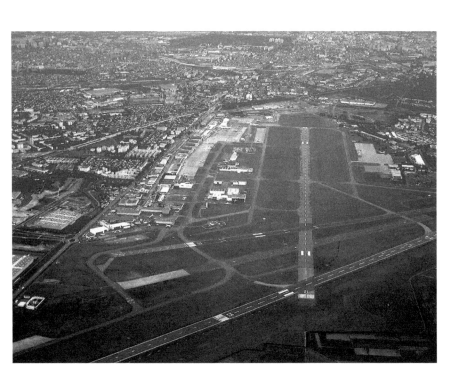

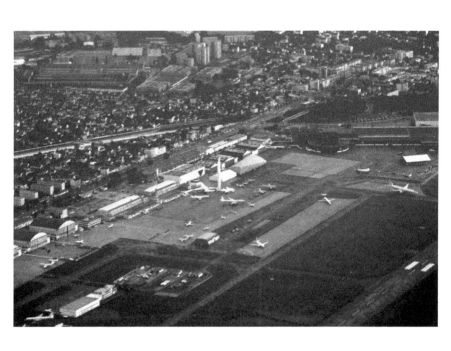

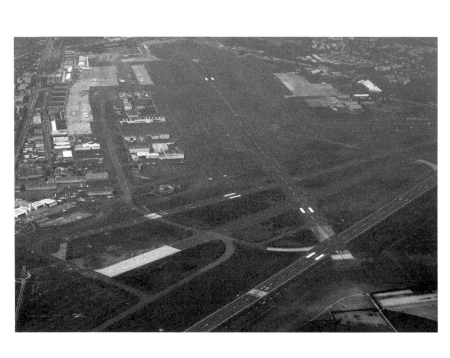

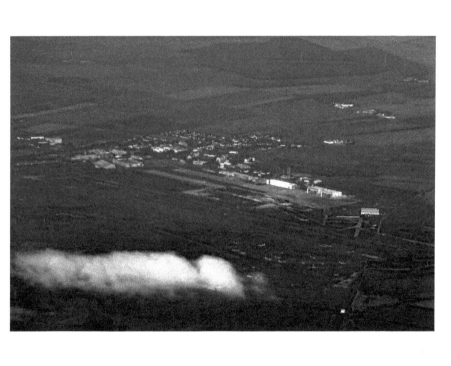

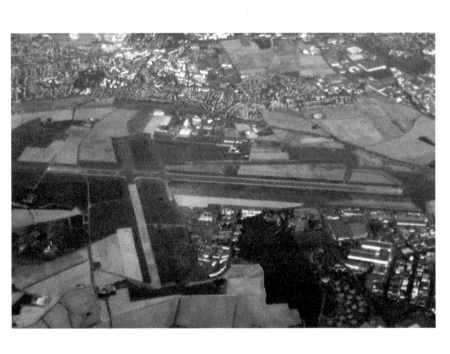

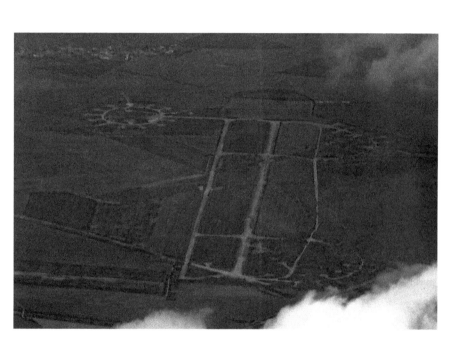

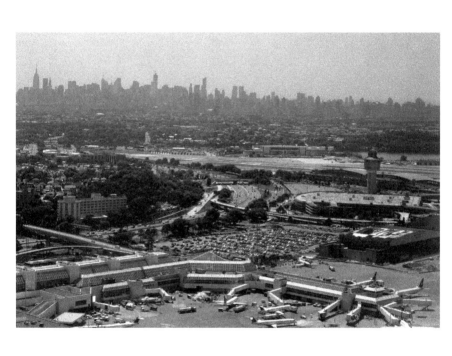

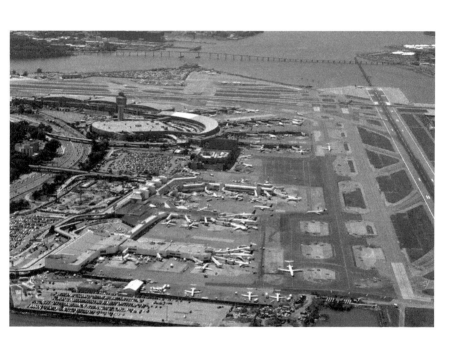

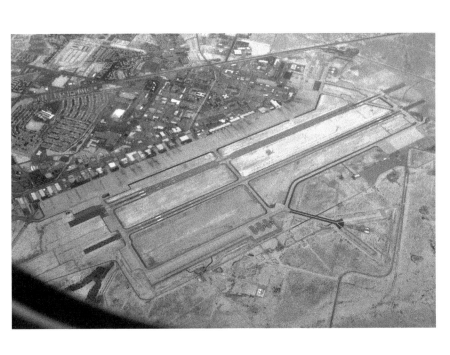

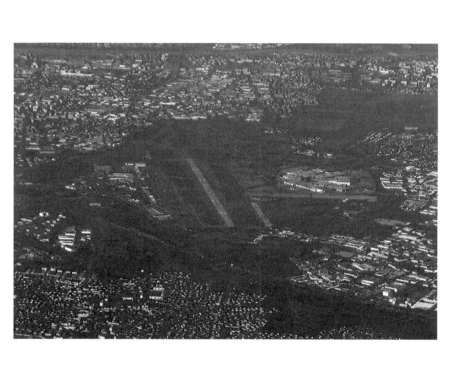

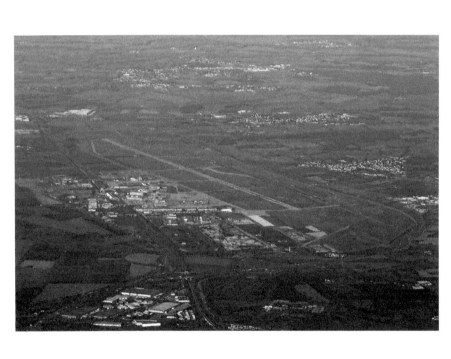

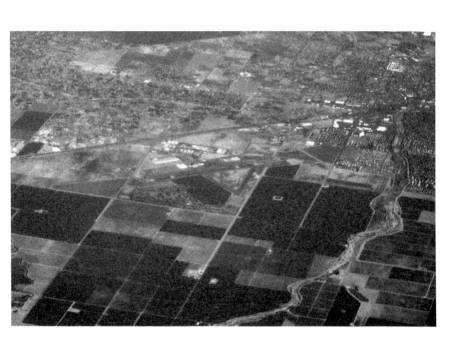

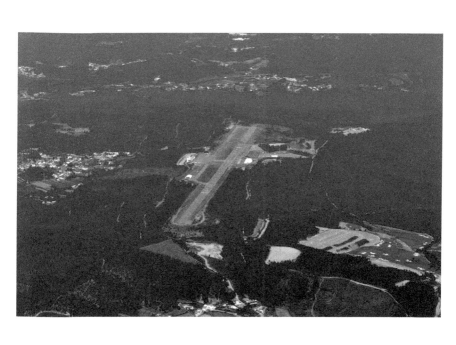

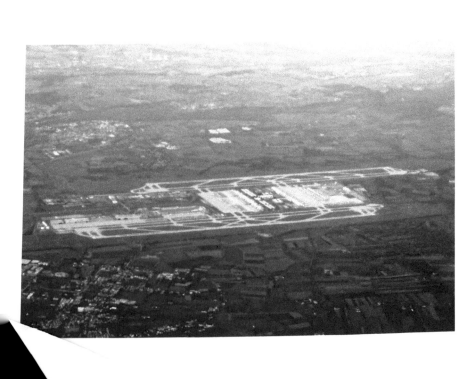

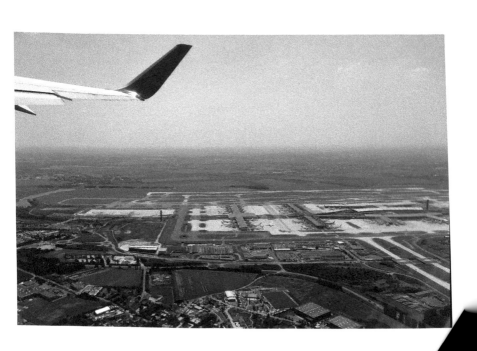

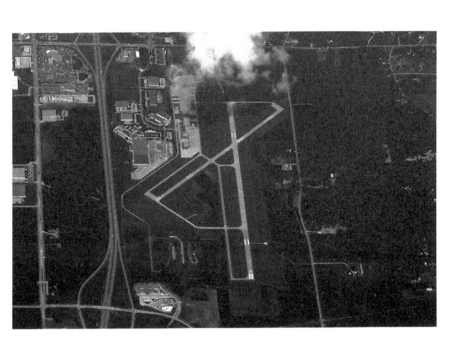

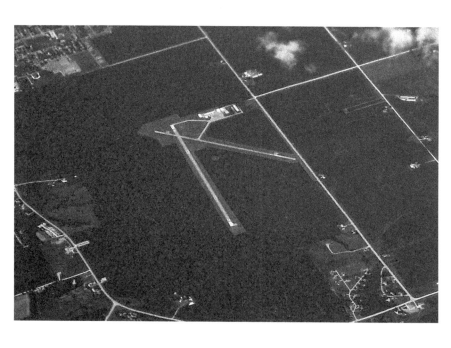

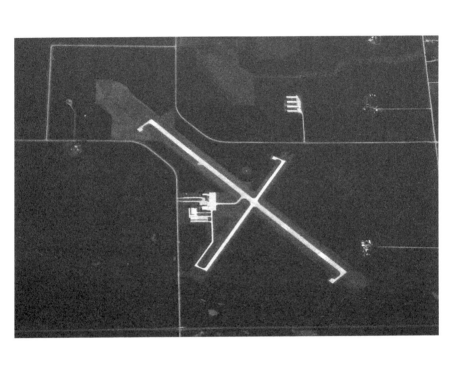

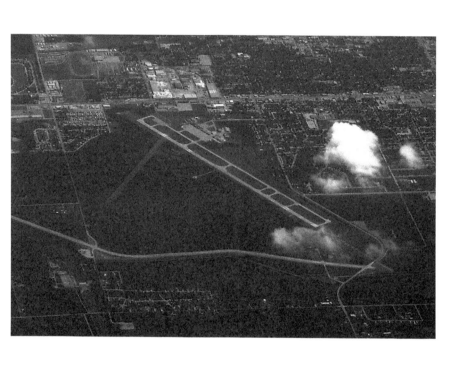

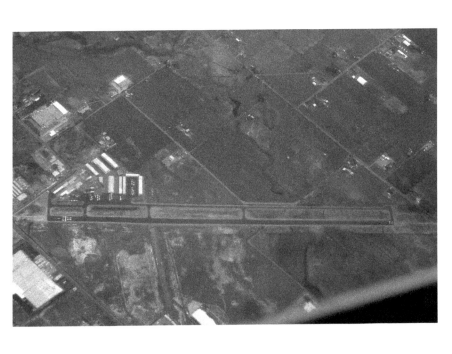

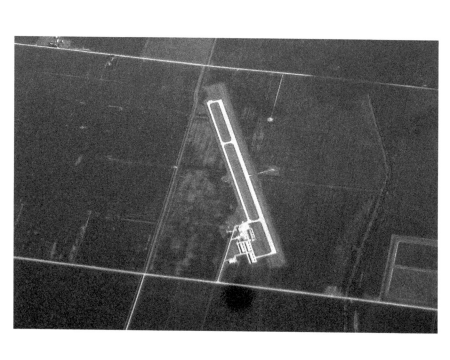

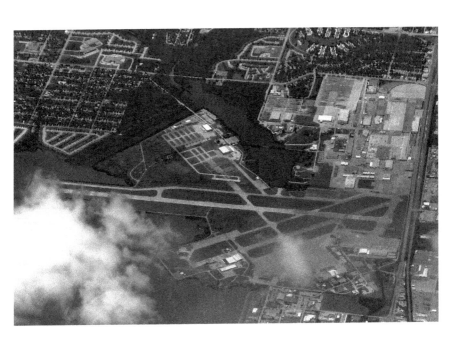

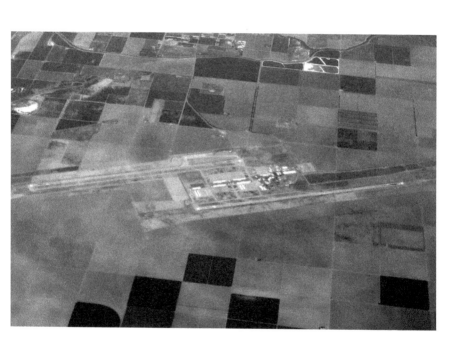

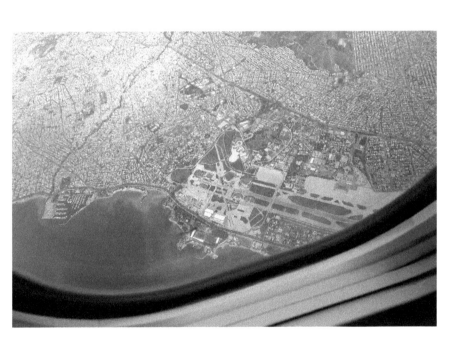

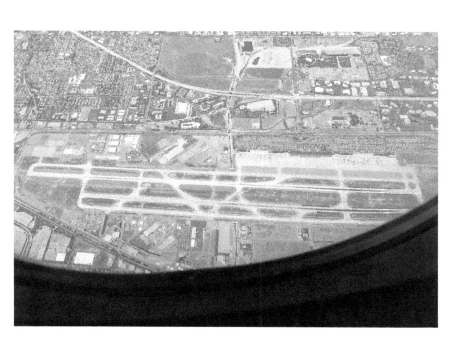

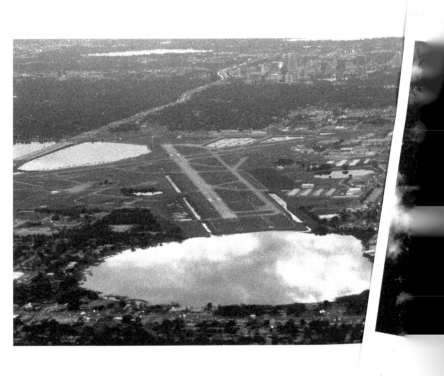

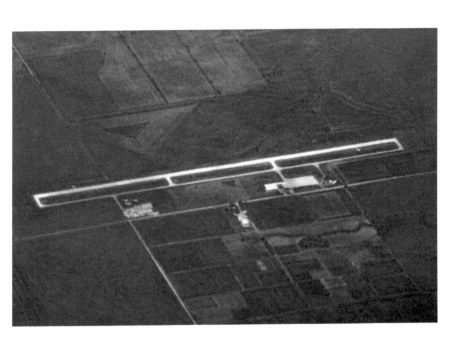

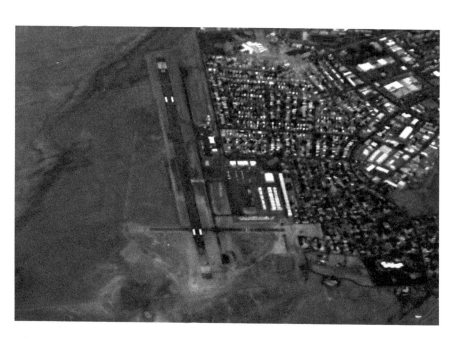

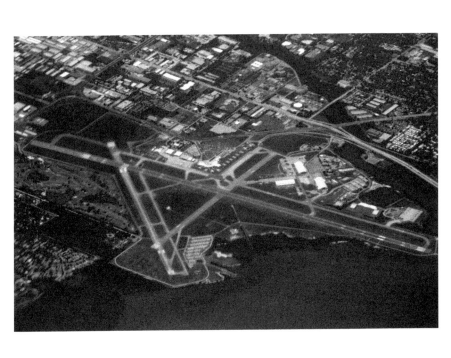

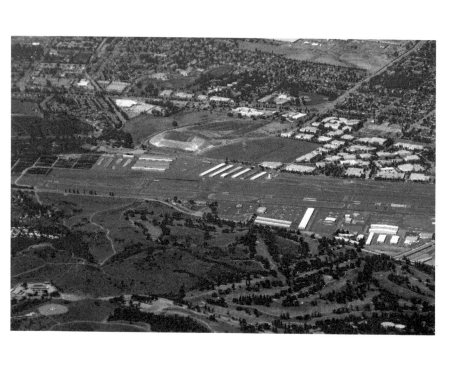

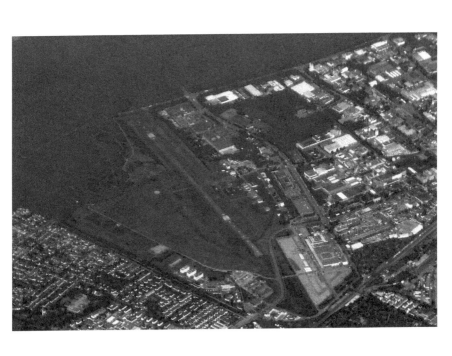

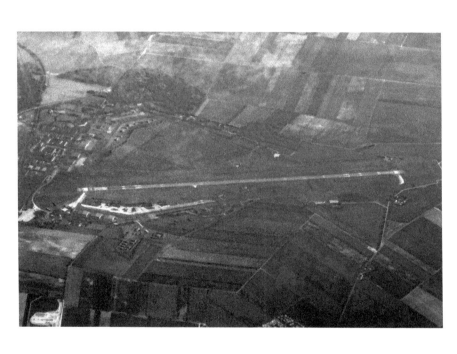

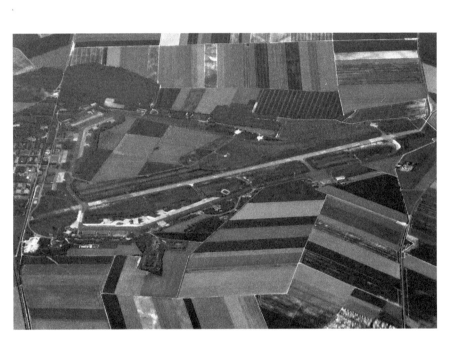

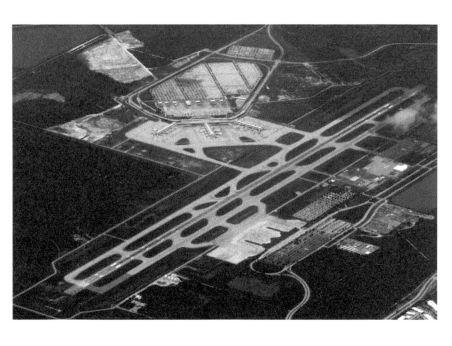

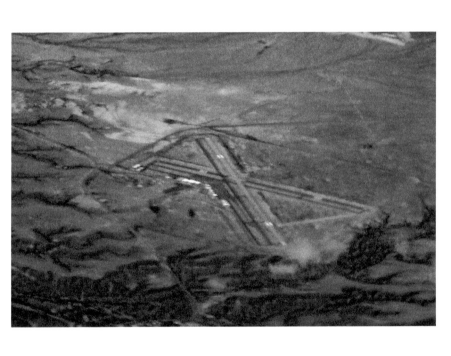

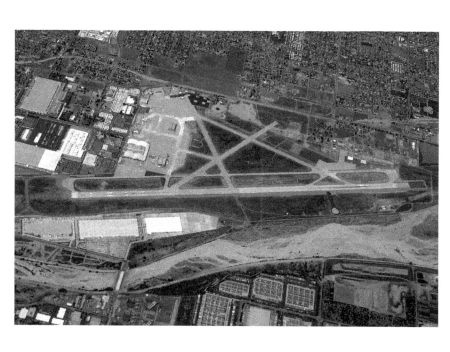

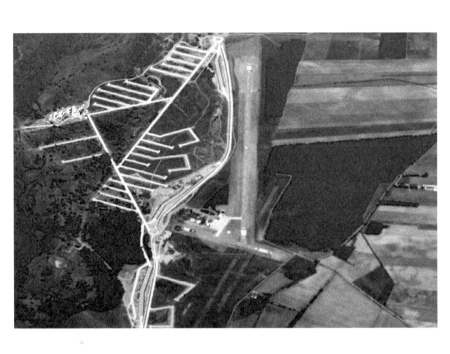

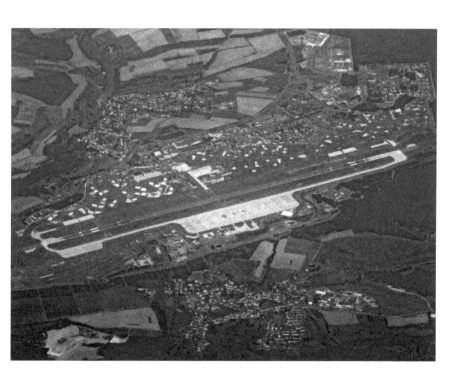

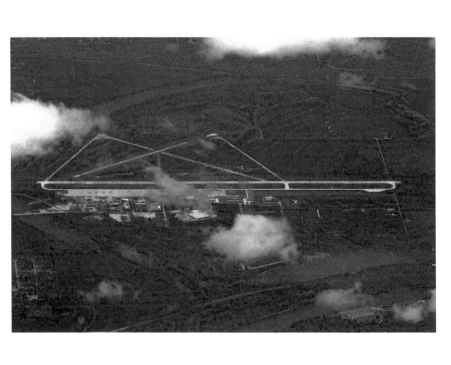

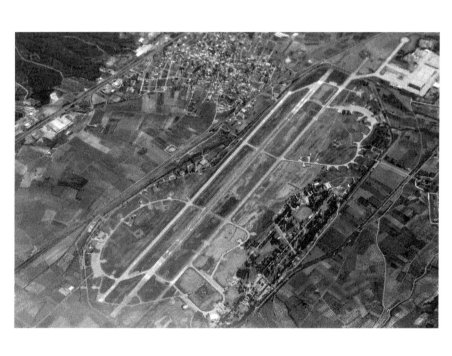

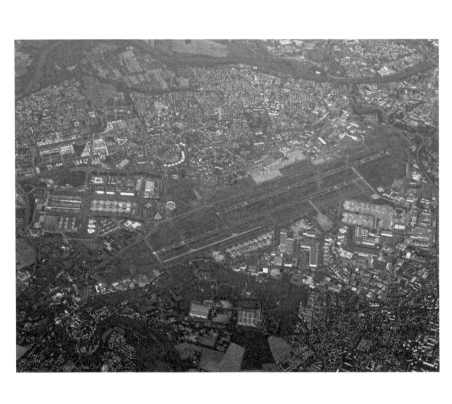

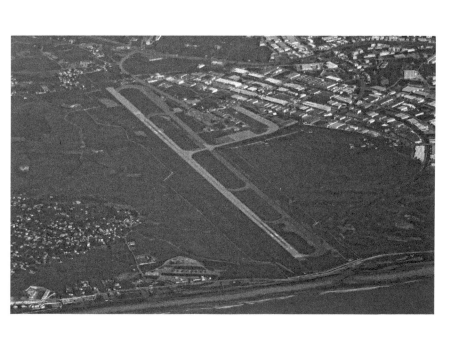

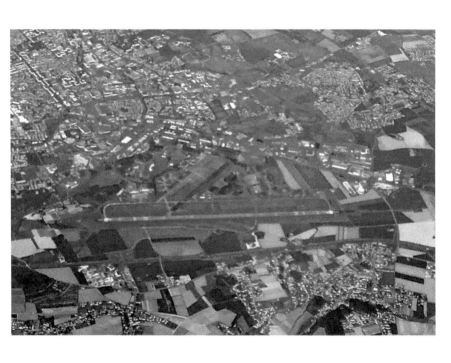

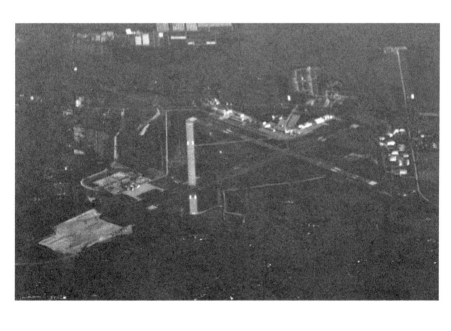

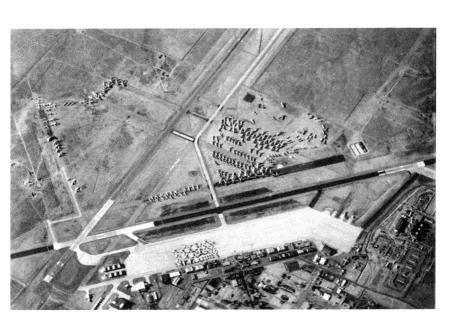

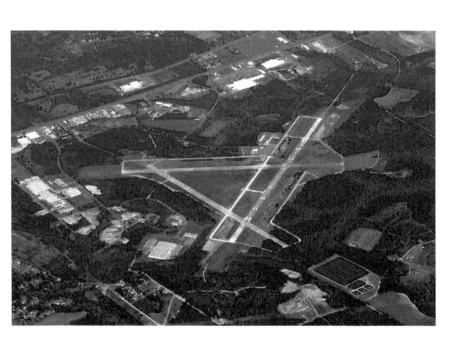

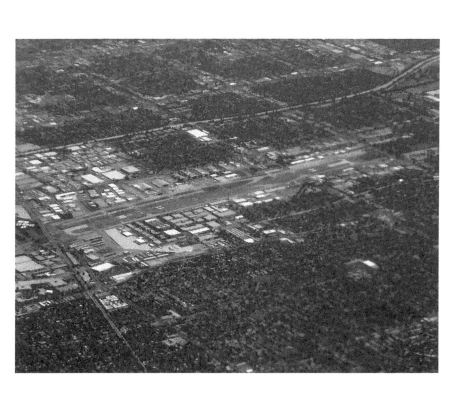

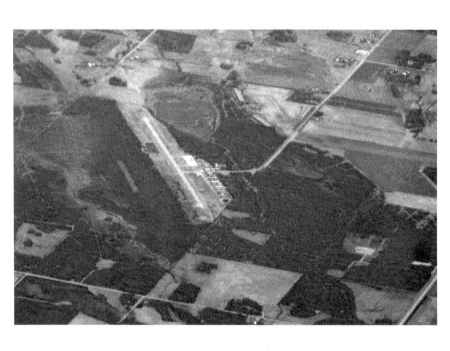

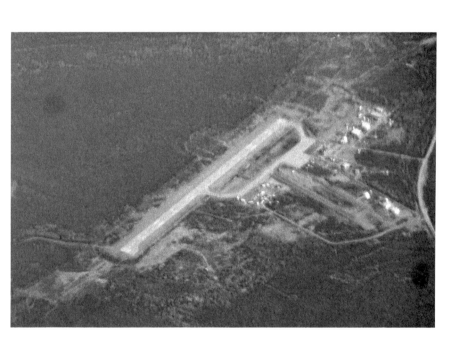

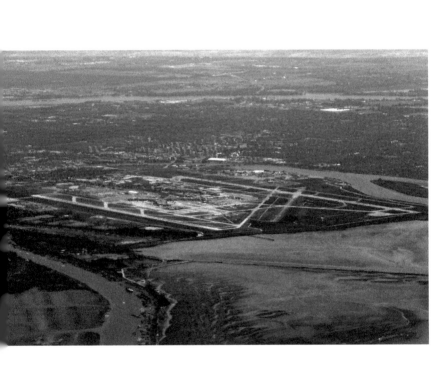

CPSIA information can be obtained
at www.ICGtesting.com
Printed in the USA
BVHW020918090919
557931BV00016B/404/P

9 780464 242512